WONDERFUL BLACKIFUL PEOPLE

Bay Area Changemakers
A to Z

art by
The Blackiful Collective
at Creativity Explored

words by
d. Wright

manic d press
san francisco

ISBN 978-1-945665-42-4

Supported in part by the California Arts Council, a state agency. Any findings, opinions, or conclusions contained herein are not necessarily those of the California Arts Council.

CALIFORNIA
ARTS COUNCIL
A CALIFORNIA STATE AGENCY

Contents

for ditto

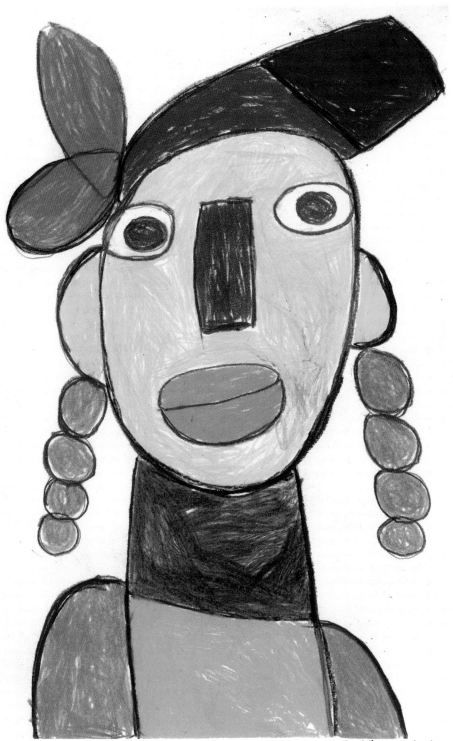

art by Vincent Jackson

ADRIAN WILLIAMS is a community activist, mother, grandmother, and executive director of The Village Project, a nonprofit organization based in San Francisco's Western Addition that works to improve the economic, cultural, educational, and social wellbeing of children in underserved communities. Born in Arkansas, Williams' family moved to Monroe, LA, before settling in Chicago, IL, where she attended elementary school. At a young age, elders in her community noticed her intelligence and urged her to "be somebody" someday. Williams took this encouragement to heart. The recipient of a National Achievement Scholarship, she attended Northwestern University where she was one of fewer than 400 Black students among thousands of undergraduates. While there, Williams participated in the May 4, 1970 protest against the Vietnam War at Kent State University where nine students were injured and four were killed when the Ohio National Guard opened fire on an unarmed crowd. After witnessing this turn of events, Williams channeled her political engagement into community activism. Williams graduated from Northwestern and moved to San Francisco, CA, taking a job in corporate sales to support herself and her family. She eventually settled in the Western Addition neighborhood, where she provided childcare for her grandchild. In 2006, responding to gun violence in the community that kept the neighborhood's children indoors, Williams began an all-volunteer summer lunch program to offer a safe space for kids to gather, learn, and play. This initiative would grow to become The Village Project. Citing the adage "it takes a village to raise a child," the Village Project has evolved and expanded over the last 16 years to include after-school academic and summer enrichment programs as well as Kwanzaa and Mardi Gras celebrations. In recent years, Williams expanded the program to support food-insecure seniors by delivering food bank groceries to community elders, many of them living in subsidized housing. Williams' community activism has earned her recognition from the San Francisco Board of Supervisors, the Mayor's Office of Neighborhood Services, and the San Francisco Public Library.

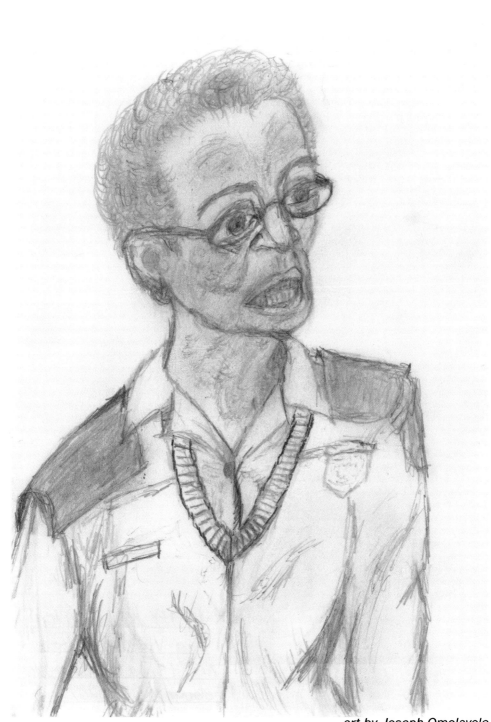

art by Joseph Omolayole

BETTY REID SOSKIN is an activist, mother, author, and retired park ranger for the National Parks Service. Born in Detroit, MI, to Cajun-Creole parents, Soskin relocated to Oakland, CA, when the Great Mississippi Flood of 1927 destroyed her family's home and business. Throughout World War II she was a file clerk for a segregated section of the Boilermakers Union, which at the time also excluded women. After the war, she and her former husband, Melvin Soskin, founded Reid's Records to provide music for the local Black community that was not readily available elsewhere. By the time of its 2019 closing, Reid's Records was the longest operating record store in California and one of San Francisco Bay Area's oldest Black-owned businesses. In her mid-eighties, Soskin became a Park Ranger at the Rosie the Riveter WWII Home Front National Historic Park Museum in Richmond, CA. She served the United States through the National Park Service until the age of 100, making her the oldest park ranger at the time of her retirement in 2022. As part of the park's interpretive programs, Soskin gave tours that wove her personal story into larger historical narratives of WWII era. As a primary source, Soskin often worked to correct the oversight of Black individuals' histories in official accounts of wartime activities. A perennially active community member, Soskin also served on the Berkeley City Council and as a field representative for two California State Assembly members. In 2018, she published Sign My Name to Freedom, a memoir detailing her remarkable life story. Known for her sentiment that "[w]hat gets remembered depends on who is in the room doing the remembering," Soskin has been an outspoken advocate for centering marginalized narratives in official historical records.

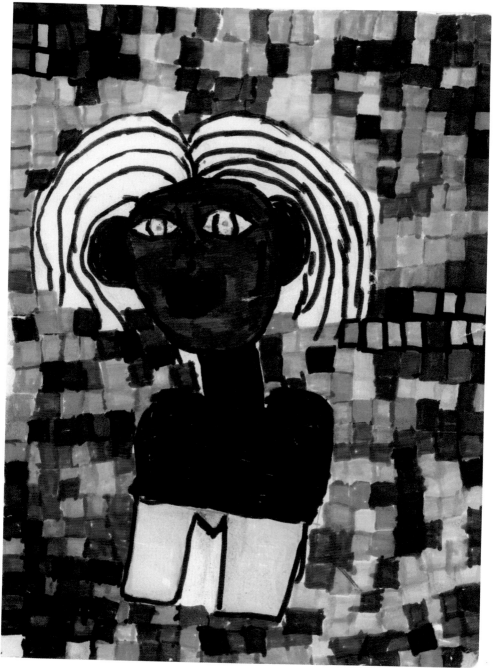

art by Alissa Bledsoe

CARROLL FIFE is an activist, organizer, mother, and Oakland City Council member currently representing Oakland's District 3. Elected in 2020, Fife works to redirect resources to community members most in need, and hopes to open doors for other grassroots organizers to get involved with local governance. Formerly the executive director of the Alliance of Californians for Community Empowerment's Oakland chapter, Fife is also a founding member of Moms 4 Housing and a vocal advocate for tenants' rights. Fife moved to California at the age of 21, earning a bachelor's degree in human services from Holy Names University and pursuing a master's degree in urban education. As a resident of Oakland, she has witnessed firsthand the housing instability that has displaced much of the city's Black population over the past two decades. In 2022, Fife hosted a symposium aimed at developing a Black New Deal, bringing together activists, scholars, and community members to imagine what reinvestment in Oakland's Black communities might look like. An outspoken advocate for divesting from police and revamping public safety by channeling funds to community initiatives, Fife makes a point to draw connections between the city's ever-increasing police budget (which accounts for almost half of the city's general fund) and the corresponding lack of resources for other priorities like community health initiatives and housing. In an effort to address the unaffordable-housing crisis, Fife introduced Measure Q to rollback Article 34 of the California Constitution, a 1950 amendment passed to prevent building public housing without voter approval, which had been created by the California Association of Realtors to stoke white voters' fears about neighborhood integration. Measure Q, passed by Oakland voters in 2022, provides local authority to build low-income rental units to help ease the housing crisis.

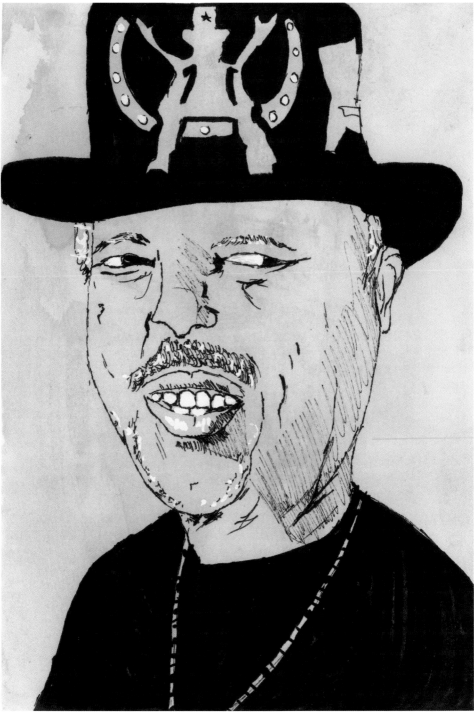

art by Joseph "JayD" Green

DAVID G. MILES, JR. is a community activist and roller-skating advocate known to many in the Bay Area as the "Godfather of Skate." Born in Kansas City, MO, to a single mother, Miles dropped out of high school and enlisted in the military before following his mother to San Francisco in 1979. On his third day in the city, Miles encountered roller skaters enjoying Golden Gate Park. The next day he bought a pair of skates and has been skating ever since. As the popularity of roller skating exploded in San Francisco in the late 1970s, the sport created concern for the community surrounding Golden Gate Park. In response, Miles and his fledgling crew of skating enthusiasts partnered with the San Francisco Recreation and Parks Department to create a Skate Patrol that allowed people to continue skating in designated areas. Miles also fought to create a protected space for the community he helped cultivate, securing an agreement with city officials to keep a section of Sixth Avenue closed off to cars. Initially launched as a 30-day trial, the temporary experiment eventually became a permanent beloved fixture in the park. In 2013, Miles created the Church of Eight Wheels, transforming a condemned church into a roller rink that hosts lessons, events, and a weekly roller disco. Miles brings his "rolligion" to other projects as well, including a mobile roller rink that has traveled to Burning Man for more than 20 years and The Skate Against Violence Campaign, a 450-mile California road skate from San Francisco to Santa Monica that combines community building with physical fitness. Miles, who contributed to the successful decades-long campaign to make Golden Gate Park's JFK Drive permanently car-free, has also teamed up with the East Oakland Community Development Corporation to launch the UMOJA Outdoor Roller Skating Rink at Liberation Park as part of Oakland's Black Cultural Zone, the only open skate rink currently in Oakland.

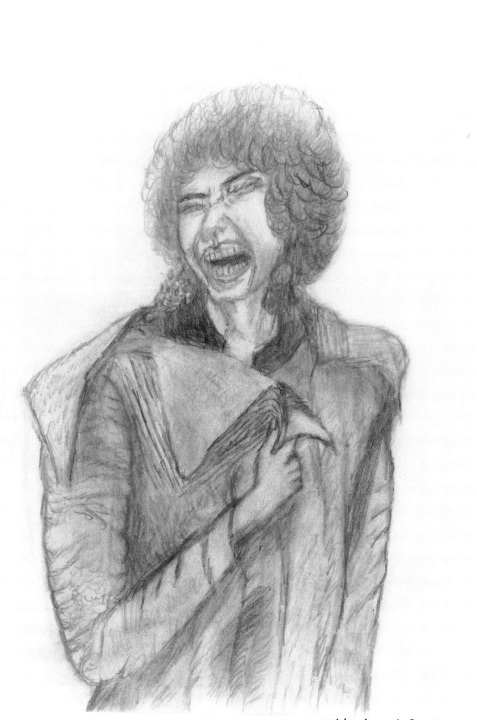

art by Joseph Omolayole

ERICKA HUGGINS is a lecturer, activist, poet, and former Black Panther known for her leadership of the Panthers' Community School. Born in Washington, DC, she attended the historically Black Lincoln University in Philadelphia, PA, where she studied education and met her future husband, John Huggins. The Hugginses soon left college to join the Black Panthers' Los Angeles chapter, which they co-led. Less than one month after the birth of their child in 1969, John and fellow Panther Alprentice "Bunchy" Carter were shot and killed. After holding a funeral for John in his hometown of New Haven, CT, Huggins opted to relocate there and start a new party chapter. She and Black Panther Party co-founder Bobby Seale were soon targeted by law enforcement: Huggins was arrested and incarcerated on conspiracy charges, where she survived solitary confinement and separation from her infant child by teaching herself to meditate. Once the charges were dropped and she was released from prison in 1971, Huggins moved back to California to work on the Panthers' *Intercommunal News Service* and to direct the Oakland Community School. Huggins led the school from 1973 to 1981, placing an emphasis on education that was student-centered, community-based, and tuition free, and which served and loved the whole child. Huggins, who later became the first Black woman to be appointed to the Alameda County Board of Education, has worked in state, county, and federal prisons and jails to bring yoga and meditation to incarcerated individuals since 1981. She has been a professor of women and gender studies at San Francisco State University, California State University, East Bay, and a professor of sociology and African American studies in the Peralta Community College District. She currently serves as a facilitator for World Trust, an organization dedicated to examining the impact of systems of oppression and racial inequality through film and visual storytelling.

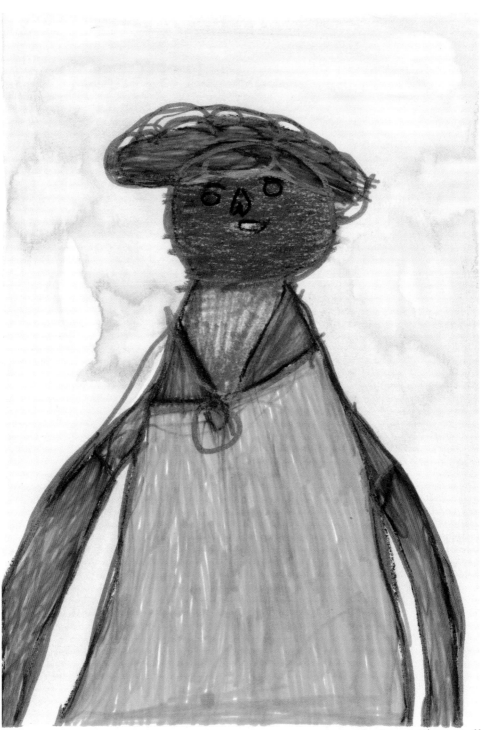

art by Laron Bickerstaff

FREDRIKA NEWTON is a former Black Panther, widow of Black Panther Party co-founder Huey Newton, and president of the Dr. Huey P. Newton Foundation. Born and raised in Oakland, CA, Fredrika was introduced to Huey by her mother, Arlene Slaughter, a Jewish housing rights activist and realtor who helped many Black families purchase homes in the Bay Area. Growing up, Fredrika recalls attending rallies and marches, and that her mother's social and political engagement had turned her off to activism. Initially hesitant to join the Panthers, she left Oakland to attend college in Oregon but soon returned and began dating Huey. Fredrika joined the Panthers and volunteered at the Community School, where Party members and their children lived, learned, and worked communally. Huey and Fredrika eventually married and remained together through the 1982 dissolution of the Party until his murder in 1989. She established the Dr. Huey P. Newton Foundation, an organization that aims to preserve and protect the Black Panthers' legacy, in 1995. The foundation prominently features the Party's original 10-point program on its website and plans to host an archive of aging Party members' oral histories in an effort to retain local knowledge. It also aims to introduce curriculum in California K-12 public schools about the Panthers' history and to establish a Center for Research and Action. In 2021, the foundation successfully installed Oakland's first public monument to the Black Panthers, a portrait bust of Huey Newton near the site of his murder. Through her work, Newton hopes to honor the legacy of the Party by claiming permanent space in the city of the Panthers' founding and providing accurate information about the Black Panthers for generations to come.

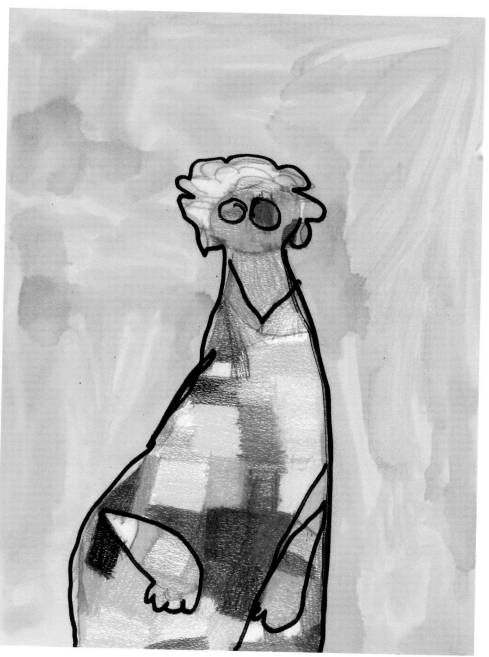

art by Laron Bickerstaff

M. GAYLE "ASALI" DICKSON is a visual artist, retired pastor, and former Black Panther known for her work on the Panthers' weekly newspaper, the *Intercommunal News Service*. Born in Berkeley, CA, Dickson honed her artistic skills throughout her education in Oakland's public schools. Dickson studied painting briefly at Laney College before transferring to Merritt College, where she joined the Black Student Union (BSU) and studied African art. In 1968, she took part in the protest of the police murder of 18-year-old Bobby Hutton, the Black Panther Party's treasurer and the Party's first recruit. In 1970, Dickson attended University of Washington in Seattle, where she joined the school's BSU and the Black Panthers' local chapter, working in their survival programs. Dickson moved back to Oakland in 1972 to work at Panthers' headquarters where she was assigned to graphic arts with Minister of Culture Emory Douglas. There she became the sole woman graphic artist for the Party's *Intercommunal News Service* where she worked until 1974. Dickson's visual art promoted the Panthers' 10-point program and highlighted the roles of women and children in the Panthers' struggle for self-determination. By 1974 she was also working in the Oakland Community School, teaching art and taking on various administrative duties. When Dickson left the Party in 1976, she found other ways of serving the people, body and soul. Graduating from Holy Names University with a bachelor of fine arts in 1986, Dickson also graduated from the San Francisco Theological Seminary with a master of divinity degree in 1998. She served as South Berkeley Community Church minister from 1998 to 2006. Though she retired in 2016, Dickson continues to serve her communities by making art, teaching, and giving talks about her life and work.

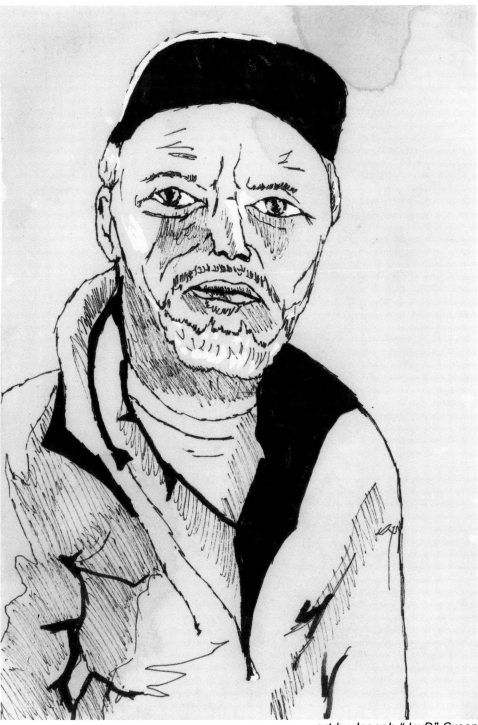

art by Joseph "JayD" Green

HORACE WASHINGTON is a visual artist who works across sculpture, murals, and time-based media to explore Black identity, culture, and social and political activism. Born in Atlantic City, NJ, Washington grew up working in his parents' locally famous soup stand. From an early age Washington viewed his art practice as a way to move beyond his segregated upbringing in New Jersey. He attended Columbus College of Art and Design in Ohio from 1965 to 1968 and studied sculpture at the San Francisco Art Institute and California State University, Sacramento. In 1973, Washington worked with Caleb Williams to co-create an Afrofuturist-inspired mural at the Plaza East Housing Project, a public housing development in San Francisco's Fillmore neighborhood. In the 1980s, he collaborated with nine other artists to create a public mural-sculpture in downtown San Francisco honoring two longshoreman union workers who were fatally shot during the International Longshore and Warehouse Union's historic 1934 Waterfront Strike. While working on the mural, Washington was recruited to develop a ceramics program for Creativity Explored, an art studio established in San Francisco's Mission District in 1983 to support artists with developmental disabilities. Washington taught there from 1983 to 2019. A lifelong educator, he also has been a guest lecturer at colleges and universities, including the University of California, Berkeley, California State University, Sacramento, and University of Arizona at Tucson. In 1987, Washington designed a cast concrete piece celebrating the history of the Fillmore district for the Western Addition's Northern Police Station. Washington later served as lead artist for the Third Street Light Rail Kirkwood/Oakdale station in Bayview-Hunters Point, drawing inspiration from the neighborhood's history of shipbuilding. For the last 15 years, Washington has also explored the moving image, conducting interviews with local artists about their work and publishing them on his public YouTube channel. Washington has made a selection of these recordings available through the San Francisco Public Library, creating an accessible archive of artists' practices for the local community.

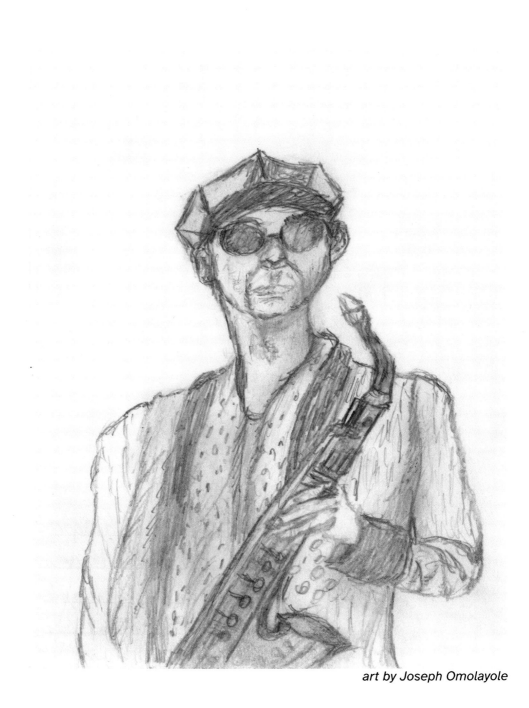

art by Joseph Omolayole

IDRIS ACKAMOOR is a composer, multi-instrumentalist, and the founder and bandleader of the Afrofuturist musical group, The Pyramids. Born Bruce Baker, Ackamoor grew up in Chicago, IL, where he studied music from the age of 12. In 1968, Ackamoor briefly left Chicago to attend college in Cedar Rapids, IA, on a basketball scholarship but soon returned to work with Clifford King, who mentored many of Chicago's musicians through the famed Association for the Advancement of Creative Musicians. Ackamoor transferred to Antioch College in Yellow Springs, OH, in 1970 where he met Margo Simmons and Kimathi Asante, founding members of The Pyramids. As part of Antioch's work-study program, Ackamoor traveled to Los Angeles where he began playing with Simmons and Asante in Cecil Taylor's Black Music Ensemble. There Taylor, who became Ackamoor's mentor, encouraged students to draw inspiration from African musical traditions. Ackamoor leveraged the college's study abroad program to continue traveling with Simmons and Asante, first to Paris to study French, then to Amsterdam where The Pyramids were officially formed. The group spent a transformative year traveling and studying music in Morocco, Senegal, Ghana, Uganda, Kenya, and Ethiopia. The Pyramids brought back ceremony, distinctive costumes, and stage magic to their subsequent performances, incorporating Afrofuturistic theatricality as well as distinctly African instruments. In 1977, the original band split up, but their three albums, *Lalibela*, *King of Kings*, and *Birth/Speed/Merging*, are considered notable contributions to Afrofuturist and avant-garde jazz canons. In addition to his ongoing work with The Pyramids, Ackamoor also provides the artistic and administrative direction for Cultural Odyssey, a nonprofit production company based in San Francisco that he co-leads with his partner, Rhodessa Jones, a celebrated performance artist who produces performance workshops for incarcerated women aimed at personal and social transformation.

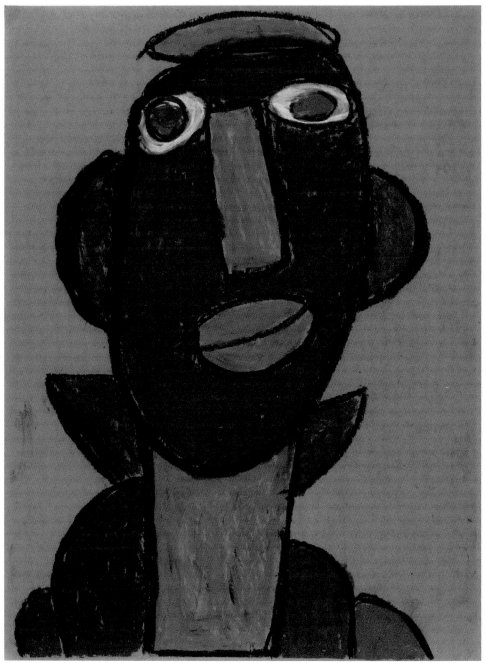

art by Vincent Jackson

JIM JACOBS is a retired educator and librarian who became the City of Berkeley's first Black librarian. Jacobs began his career at the Berkeley Public Library shelving books in 1958 while he attended graduate school at University of California, Berkeley. At the time, Jacobs was the only Black student in the UC Berkeley master of library science graduate program. In 1960, he became Berkeley Public Library's first African American librarian. During his tenure, he noticed that books written by Black writers were shelved together under the category of "Slavery and Emancipation" along with other general interest books about Black American history. Jacobs responded by leading the effort to reorganize Berkeley Public Library's collections to desegregate the content and appropriately categorize titles based upon each work's content and genre. Jacobs was also an early supporter of equity in gender representation, consciously incorporating books that featured female protagonists in children's story times at his library. Jacobs also began the Berkeley Public Library's first Summer Reading program at his branch. His program would be recreated citywide and became a foundational part of the library's offerings, fostering literacy and cultivating a lifelong love of reading for the Berkeley community. Honored in 2021 by the Berkeley mayor for his many contributions to the community throughout his years of service, Jacobs is recognized for inspiring generations of readers.

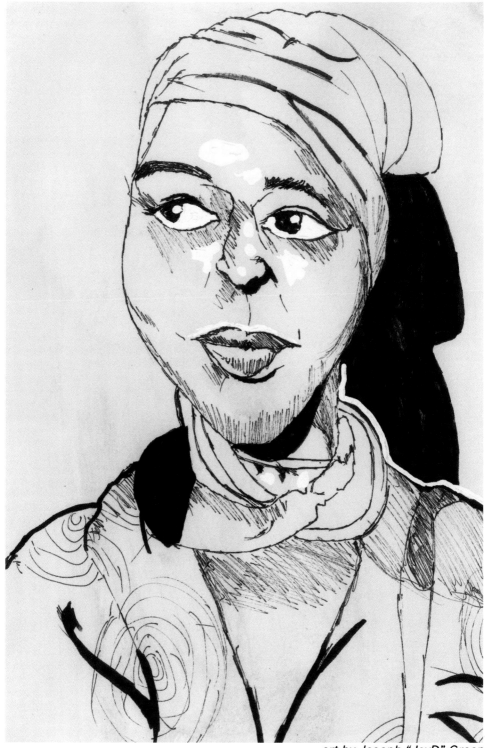

art by Joseph "JayD" Green

KAREN SENEFERU is a visual artist, activist, educator, and curator whose work centers and honors Black women. Born in Oakland, CA, Seneferu grew up deeply influenced by the Black Panthers' revolutionary politics and their emphasis on love as acts of service and cultural pride. Seneferu earned a bachelor of arts degree in English from the University of California, Berkeley and began teaching English and art classes at many Bay Area colleges. A self-taught multidisciplinary artist who came to art practice later in life, Seneferu creates soft sculptures, multimedia art, and performances that explore Black culture and identity throughout the African diaspora. Seneferu has dedicated herself to being an educator and "artivist," and to creating spaces for Black women to gather and celebrate their divinity. She is the driving force behind *The Black Woman is God*, a recurring exhibition and online gallery co-curated with Melorra Green that highlights the creative contributions that Black women artists have made to cultures and communities across the globe. Karen's husband, MALIK SENEFERU, is also a well known visual artist, musician, poet, painter, educator, and facilitator. A Bay Area native, Malik grew up in public housing in San Francisco's Hunters Point neighborhood. Also a self-taught artist, Malik creates paintings, murals, and mixed media projects that explore memory and Black cultural identity. Malik, who sees art as a way to liberate his imagination, has exhibited extensively in the Bay Area as well as nationally and internationally. In 2020, Malik collaborated on the Fillmore district's Black Lives Matter mural to foreground the housing crisis's deep impacts on Black residents of San Francisco. When not making his own work, Malik also teaches art to incarcerated youth.

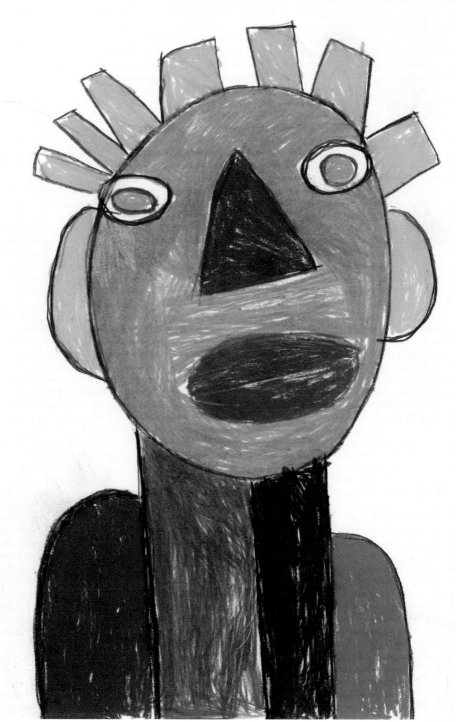

art by Vincent Jackson

LENN KELLER was an artist, photographer, filmmaker, curator, Bay Area historian, and self-described "proud butch lesbian" notable for co-founding the Bay Area Lesbian Archives. Born in Evanston, IL, to a family of sharecroppers, Keller grew up in the suburbs north of Chicago and was one of four Black students in her high school class of 1,200. Keller relocated to New York City shortly after graduation where she found a creative community of fellow Black artists and musicians who nurtured her interest in photography and filmmaking. Keller moved to the Bay Area in 1975 and quickly immersed herself in local Black queer culture. She also continued to develop her artistic practice, receiving a degree in visual communication from Oakland's Mills College in 1984. Keller's interest in documentary photography blended activism with art: she was rarely seen without her camera, documenting rallies, marches, and other radical movement work. She also produced two short films: *Ifé*, a five-minute piece documenting a day in the life of a Black French lesbian, and *Sightings*, a 15-minute film featuring an all-women cast and crew. In 2014, Keller began collecting stories and a range of materials from the local lesbian community, noting that these histories were of critical historical importance to preserve. Keller observed that while the Bay Area had an abundance of LGBTQIA+ material, it was mainly representative of cisgender white gay men. Keller's legacy addresses this lack of representation, bringing the margin to the center while examining the risks and rewards of queer Black visibility and representation. Remembered as living a life of prefigurative politics (or creating the world she wanted to live in), Keller's dedication to promoting underrepresented histories preserved cultural heritage that might otherwise have been forgotten or overlooked.

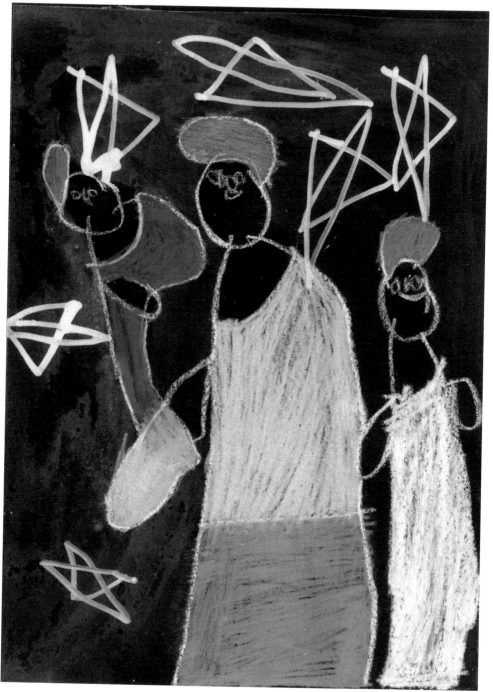

art by Laron Bickerstaff

MOMS 4 HOUSING is a collective of Black unhoused and housing insecure working mothers who believe housing is a human right. In November 2019, the moms engaged in an act of civil disobedience by moving into an unoccupied house located at 2928 Magnolia Street in West Oakland, CA. The property, which had been vacant for two years, was owned by the real estate investment firm Wedgewood Properties. Initially the Wedgewood company refused to negotiate with the moms, whom they labeled as criminals. As the moms' occupation attracted media attention, the real estate speculator switched tactics, offering to pay for moving expenses and two months' rent to each of the mothers in exchange for vacating the property. When the moms refused, Wedgewood moved to evict the mothers, claiming the activists were squatting on private property. The mothers fought back in court, arguing that they had a "right to possession" citing the United Nations 1948 Universal Declaration of Human Rights that includes a right to adequate housing. An Alameda County judge ruled in Wedgewood's favor, ordering the moms to vacate the property. Sheriffs followed this order by executing a militarized pre-dawn eviction, breaking down the property's door and arresting two of the moms onsite. Hundreds of community members mobilized in response, which drew local and national news coverage and prompted Oakland mayor Libby Schaaf and California governor Gavin Newsom to get involved. Lawmakers ultimately brokered a deal that allowed Wedgewood Properties to sell the West Oakland home to the Oakland Community Land Trust, which completed the building's rehabilitation in 2021. The property, known colloquially as the Moms House, is now operated by the moms as transitional housing for other mothers and their children.

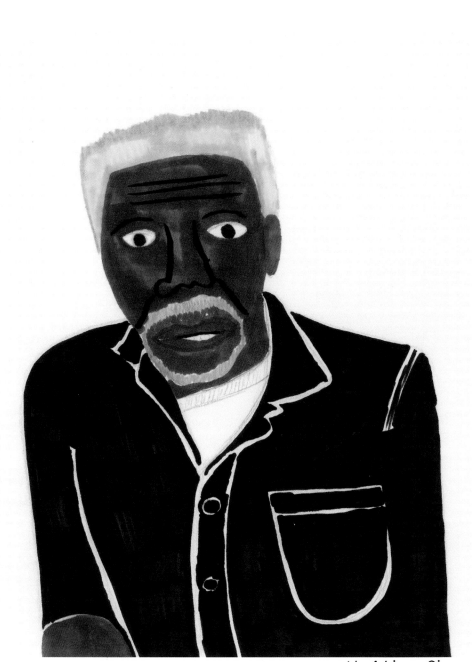

art by Adrianna Simeon

NATHAN HARE is an award-winning retired professor of sociology, clinical psychologist, author, and scholar known as the "Father of Black Studies." Born in Slick, OK, Hare experienced racism and segregation growing up in Oklahoma. As a child he'd hoped to become a professional boxer, but a teacher of his suggested that he focus instead on his education. Hare followed that advice, receiving a BA degree from Langston University and both MA and PhD degrees in sociology from University of Chicago. In 1961, Hare began teaching sociology at Howard University in Washington but was fired in 1967 after vocally protesting the university president's plan to make the historically Black university's student body sixty percent white by 1970. In 1968, Hare began working at San Francisco State College (now San Francisco State University) as the program coordinator for the school's Black studies program, where he coined the term "ethnic studies." Hare would lose his job there, too, after he refused to support interim college president S.I. Hayakawa's efforts to end the historic strike led by students and faculty. Hare co-founded a prestigious academic journal, *The Black Scholar: A Journal of Black Studies and Research*, in 1969, and earned a second doctorate in clinical psychology from the California School of Professional Psychology in 1975. He later worked as a clinical psychologist in private practice in San Francisco and Oakland. He also co-founded the Black Think Tank with his wife, Julia, to address concerns in the Black community, and co-wrote several books, including *The Endangered Black Family*, *The Miseducation of the Black Child*, and *Crisis in Black Sexual Politics*.

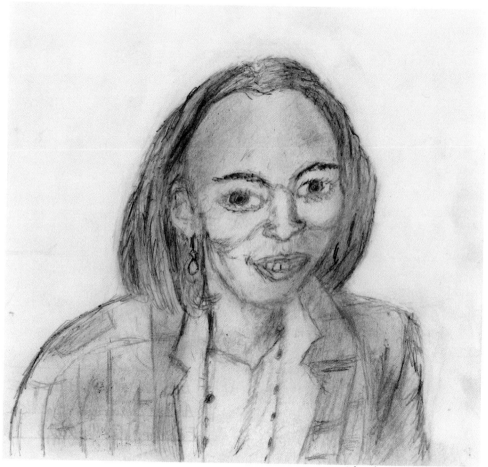

art by Joseph Omolayole

ODETTE POLLAR is an author, speaker, columnist, consultant, and community archivist of the Rainbow Sign, a former hub for many Black writers, artists, and thinkers to connect, perform, exhibit their work, and organize in Berkeley, CA. The daughter of Rainbow Sign co-founder Mary Ann Pollar, Odette works to preserve the deeply impactful cultural center's legacy. The center, which Mary Ann ran out of a renovated funeral home, operated from 1971 to 1977, ultimately closing during an economic downturn in the late '70s as the founders lacked the funds to purchase their building. Run as a nonprofit and largely existing on membership dues, the Sign had many functions: it served as music venue, cultural center, restaurant, and exhibition space, but according to Mary Ann, it was ultimately a pedagogical endeavor. Mary Ann and a group of other Black community leaders envisioned that every aspect of the center would model the values and best practices required to cultivate a diverse and sustainable coalition working for social change. The Sign's name was also significant: it had been borrowed from the lyrics of the canonical Black spiritual *Mary, Don't You Weep*: "God gave Moses the rainbow sign / No more water, but fire next time." (The lyric was also famously used for the title of author James Baldwin's 1963 book.) Baldwin, a frequent visitor to the center and a close friend of Mary Ann's, was a notable supporter who shared her revolutionary politics, believing that self-determination necessitated the kind of love that involved holding each other accountable. In addition to maintaining the archives of the Rainbow Sign, Pollar was also the creator and executive director of Oakland's Plant Exchange, a nonprofit organization that educated the local community about sustainable gardening practices and environmental justice for more than 15 years.

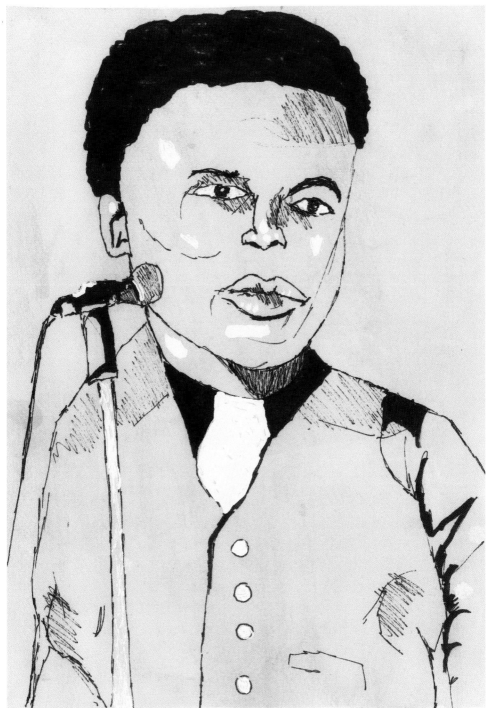

art by Joseph "JayD" Green

PAT PARKER was a Black lesbian poet, activist, feminist, and author who was an outspoken advocate for the rights of women. Born in Houston, TX, Parker was the youngest of four daughters in a Black working-class family. Encouraged by her father to leverage education in the pursuit of freedom, she earned a BA degree from Los Angeles City College. Parker moved to Oakland, CA, in 1964 to pursue her art and activism, where she became a member of the Black Panther Party and studied communist and socialist political and economic thought. After surviving a great deal of trauma growing up as well as an abusive marriage, Parker began identifying publicly as a lesbian in the late 1960s. A writer who centered her life around her activism, her poems were often rooted in frank, intimate discussions of lesbian love and desire laced with humor, poignancy, and revolutionary urgency. Parker published her first two books of poetry, *Child of Myself* and *Pit Stop*, in the mid-1970s. In 1978, Parker published *Woman Slaughter*, a poetry collection dedicated to her sister who had been murdered by her husband, followed by *Jonestown and Other Madness* in 1985. She became the director of Oakland's Feminist Women's Health Center in 1978, and two years later founded the Black Women's Revolutionary Council, a collective dedicated to educating the community about interlocking forms of oppression including racism, sexism, and classism. Parker also joined the Women's Press Collective, a publishing house led by lesbian poet Judy Grahn that prioritized the work of queer women of color. A longtime friend of poet Audre Lorde, Parker is remembered for centering her perspective as a Black lesbian feminist, and for her trenchant observations about that which prevented her and the women that she loved from thriving in community.

art by Laron Bickerstaff

Q.R. HAND, JR. was a poet, activist, and community health worker who lived and worked in San Francisco's Mission District for decades before being displaced by gentrification to Vallejo, CA. Hand grew up the oldest of three children in Brooklyn, NY, born to middle class parents—his mother was a writer and his father, who had studied at Columbia University, served his community as a pharmacist. In the 1950s, Hand attended a Christian boarding school in Massachusetts followed by Amherst College, and soon after became interested in Black liberation politics. His poems first appeared in 1968's *Black Fire*, an anthology of Black writers put together by poet Amiri Baraka and playwright Larry Neal. He moved to San Francisco in 1970 and read his poetry at cafés in North Beach, a bohemian area of the city that was once home to Beat writers including Allen Ginsberg and Bob Kaufman. Hand also read his work at bars and poetry venues around the city, joining the poets at Cafe Babar where he was a fixture throughout the '80s and '90s. (Before it closed in 1999, Cafe Babar was a small bar in San Francisco's Mission District that hosted weekly open mic poetry readings.) Hand was also a member of wordWind Chorus, a poetry/jazz performance group that included local Black musicians and poets. Beyond jazz, he also appreciated salsa, calypso, and ska music, all of which influenced the rhythms of his work. Hand published three poetry collections: *i speak to the poet in man* (1985), *how sweet it is* (1996), and *whose really blues* (2007). In the *whose really blues* foreword, Hand writes, "my real education began in the civil rights/Black power – then on to human liberation movement(s), anti-poverty programs and human service programs." In addition to his poetry, Hand worked for many years as a community mental health provider, serving as a counselor in transitional housing and supporting people recovering from mental health crises, depression, and drug addiction.

art by Laron Bickerstaff

DR. RAYE & JULIAN RICHARDSON were activists, community organizers, and the founders of Marcus Books, the nation's oldest Black-owned bookstore. Dr. Raye Richardson was born in Brinkley, AR, and raised in Waukegan, IL, by her father. She attended Tuskegee Institute where she met her future husband, Julian Richardson. In 1946, the couple, who would remain married for 60 years, arrived in San Francisco, where Julian soon established Success Publishing Co., a printing company in the Fillmore district. They went on to found Marcus Books in 1960, a store that explicitly stocked and published books by and about Black people. They named the store for Marcus Garvey, a notable Jamaican political activist and Black nationalist. Their San Francisco location not only provided refuge for Black intellectuals in the Bay Area, it also offered meeting space for dozens of organizations to help them get established, including the Black Firefighters Association, the Association of Black Policeman, and the Black Nurses Association. As "urban renewal" policies devastated the Black community that once thrived in the Western Addition, Marcus Books relocated several times to avoid demolition before settling in the Fillmore in 1981. The family would be forced to close the San Francisco bookstore in 2014 after more than 50 years in operation despite the location being designated a San Francisco landmark in 2013. The bookstore's Oakland location, which opened in 1976, remains open for business and is now co-owned by the Richardsons' children. It has become a literary and cultural hallmark that has hosted an array of luminary Black authors and cultural figures including Toni Morrison, Rosa Parks, Muhammad Ali, Maya Angelou, Angela Davis, and many more. In addition to co-founding Marcus Books, Dr. Raye also served for decades as the chair of the Black studies department at San Francisco State University where she taught critical thinking as well as literature and humanities classes.

art by Joseph "JayD" Green

SADIE BARNETTE is an Oakland-based visual artist primarily known for work that engages with her father RODNEY BARNETTE's FBI file and personal history. Born in Oakland, Barnette earned a BFA degree from the California Institute of the Arts and an MFA from the University of California, San Diego. She works across drawing, photography, and installation to explore political repression through a retelling of her family's history. Her best-known work makes use of her father Rodney Barnette's 500-page FBI file that was accrued through his work with the Black Panther Party. Mr. Barnette was the founder of the Party's Compton chapter in 1968. While organizing with the Panthers, he was fired from his job as a US Postal Service letter carrier in Los Angeles. Mr. Barnette often wondered about this and other adverse experiences he'd had that seemed related to surveillance by COINTELPRO, an FBI counterintelligence program that consisted of covert and illegal directives meant to divide, disrupt, and "neutralize" the Panthers, as well as other politically active organizations. (FBI chief J. Edgar Hoover would oversee COINTELPRO as part of his 37-year tenure, which ended with his death in 1972.) The family eventually requested Mr. Barnette's files through the Freedom of Information Act. This process, which took approximately five years, was ultimately successful. Once acquired, Sadie soon began working the 500-page archive into her practice, incorporating redactions, glitter, and various shades of pink spray paint in installations that turn a critical eye toward the deeply intimate subject matter. Barnette's interventions have been described as evoking vandalism as well as childlike playfulness in an attempt to undermine the government's ever-watchful gaze. In 2023, Sadie mounted an imagined recreation of Mr. Barnette's New Eagle Creek Saloon, San Francisco's first Black-owned gay bar, at the San Francisco Museum of Modern Art, as well as The Lab and the Institute of Contemporary Art, Los Angeles. Through her work with inherited family histories, Barnette hopes to celebrate Black power, joy, and resistance.

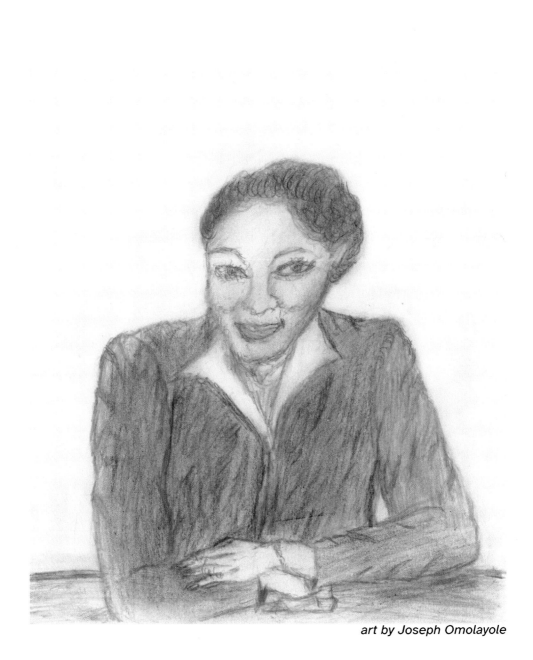

art by Joseph Omolayole

TAREA HALL PITTMAN was a civil rights activist, social worker, and community organizer known for her regional leadership of the NAACP (National Association for the Advancement of Colored People). She was born in Bakersfield, CA, where her father was a farmer and blacksmith who had moved from Alabama to California and co-founded the Bakersfield Branch of the NAACP with his four brothers. In the 1920s, Pittman enrolled at the University of California, Berkeley, when Black students were not allowed to live in campus housing. In the 1930s, she began working with the NAACP and the California State Association of Colored Women's Clubs, of which she was President from 1936 to 1938. There she advocated for voter registration and supportive housing for Black children who had lost their parents. In 1936, she helped found the Negro Education Council that produced "Negroes in the News," a radio program that Pittman often hosted which spread positive information about the Black community. In 1939, Pittman returned to college after having dropped out to marry and start a family, receiving a BA degree in social services from San Francisco State College. As part of her lifelong dedication to civil rights work, Pittman organized protests in the Kaiser Shipyards to promote hiring local Black workers, and led the California Council of Negro Women as President from 1948 to 1951. She also worked to desegregate the Oakland Fire Department in 1952, and successfully lobbied on behalf of the NAACP for the California Fair Employment Practice (FEP) Act, a bill that prevented employers from discrimination based on ethnicity, religion, national origin, and other protected categories, which was signed into law in 1959. From 1961 to 1965, Pittman worked as Director of the West Coast Region of the NAACP to have additional FEP laws passed in other states, including Alaska, Arizona, and Nevada. Pittman is remembered through the Tarea Hall Pittman branch of the Berkeley Public Library.

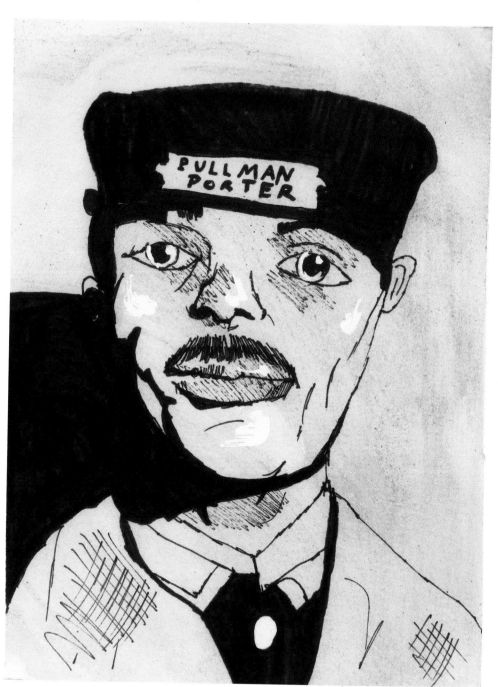

art by Joseph "JayD" Green

The **U**NION OF SLEEPING CAR PORTERS was a labor union formed in 1925 by Black employees of the Pullman Company. Led by A. Philip Randolph and C.L. Dellums, the Brotherhood of Sleeping Car Porters (BSCP) was the first international union organized by Black people. Long before air travel and automobiles, George Pullman's company operated sleeping cars that accompanied long-distance passenger trains across the country. Pullmans were like mobile hotels: the company provided a porter that attended to guests' needs, including managing their telegrams, shining their shoes, and providing room and valet services. Nearly all of the porters who provided service on these palace cars were Black men. Typically referred to as "George" regardless of their actual names, porters endured long working hours, often managing fewer than three hours of sleep per night. In response to low pay, demanding work, and long hours, porters began meeting across the country to advocate for better working conditions. In 1924, Oakland-based C.L. Dellums became a porter, earning $2 per day. The Pullman Company promptly fired him after he joined his local BSCP union, but the union quickly hired Dellums full-time as an organizer. Dellums was named West Coast vice president soon after by union president A. Philip Randolph. As VP, Dellums played a key role in winning the 1937 agreement between the union and the Pullman Company that guaranteed workers more pay and less grueling hours. After more than a decade of organizing against the company, as well as the American Federation of Labor's reluctance to recognize an all-Black union and reticence from members of the community who were fearful of retaliation, the agreement was ultimately successful due in large part to organizers on the West Coast, including Mr. Dellums, Morris "Dad" Moore (longtime porter and organizer), D.G. Gibson (founder of Oakland's first Black political club), and William Graves (Oakland-based porter).

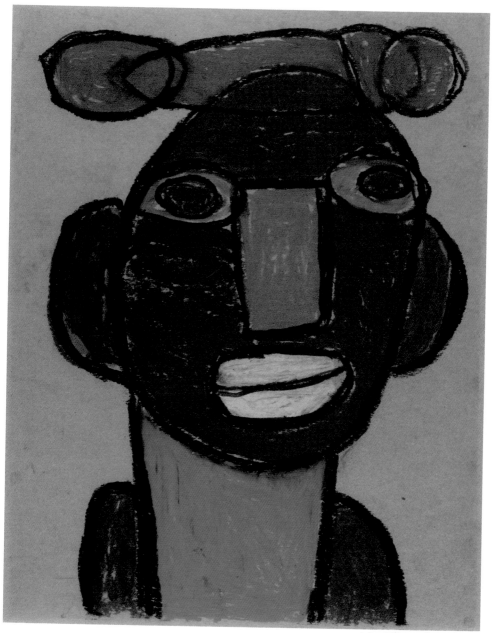

art by Vincent Jackson

VINCENT JACKSON is a San Francisco-based visual artist known for his figurative work. Born in San Francisco, Jackson grew up in a large, close-knit family in the city's Bayview neighborhood. While Jackson does not recall members of his family being artistically inclined, Jackson's grandmother taught him how to quilt at an early age. Growing up, Jackson enjoyed playing with a diverse group of children in the neighborhood and recalls the importance of attending Providence Missionary Baptist Church with his family. Jackson spent a fair amount of his time at the Bayview Opera House Ruth Williams Memorial Theatre, San Francisco's oldest theater (and a registered historical landmark), where he participated in many community programs, including making pinhole cameras, modern dance classes, and theater productions. One of the longest-practicing artists at Creativity Explored, Jackson's work has been exhibited nationally and internationally, including at New York's Outsider Art Fair, San Francisco's Yerba Buena Center for the Arts, and the Museum of Craft and Design. Jackson's work has also been featured on Recchiuti Confections' artisanal chocolates, and home décor company CB2 included his art in limited edition designs of a tote bag, throw pillow, and a ceramic vase. Over his nearly four-decade career, Jackson has developed a singular approach to the application of his chosen materials that is loose and confident, equal parts spontaneity and deliberation. A prolific artist who primarily works with oil pastel and collage (with occasional forays into acrylic paint and soft sculpture), Jackson's work features a distinct visual vocabulary, pairing his signature formula for figurative abstraction with a saturated color palette. Outspoken and elegant, Jackson is not bashful about his artistic skill or his legacy — he is proud of his status as a renowned artist and would not hesitate to tell you to "back it up" if you suggest otherwise.

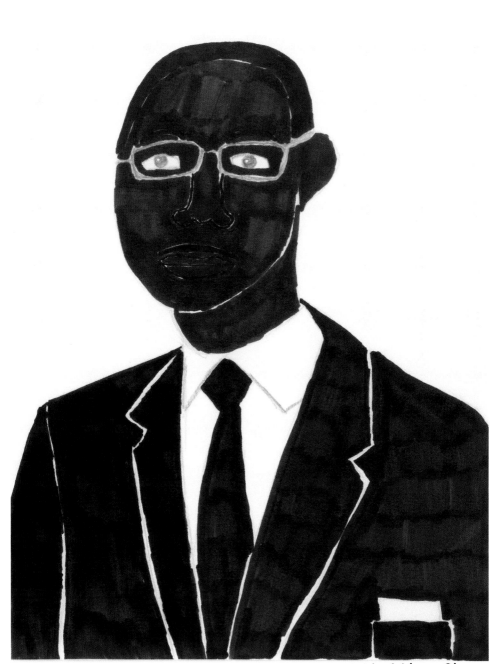

art by Adrianna Simeon

WILLIAM BYRON RUMFORD was a pharmacist, politician, civil rights activist, and legislator who fought against racial discrimination in housing and employment. The first Black official elected to a California state legislature office in Northern California representing San Francisco's 17th assembly district, Rumford was born in Courtland, AZ, and graduated from a segregated high school in Phoenix, AZ. Rumford moved to San Francisco, CA, at 18 and attended a junior college until he was accepted into University of California, San Francisco, to become a pharmacist. Graduating in 1931, Rumford successfully appealed discrimination in his exam process to be granted state certification and soon became the first Black person to be hired at Highland Hospital in Oakland, CA. In 1942, Rumford was appointed to Berkeley's Emergency Housing Committee, where he worked to provide more integrated housing options for wartime laborers. He also helped organize the Berkeley Interracial Committee, which fought against Japanese American internment and worked to establish a human relations commission in Alameda county. In 1948, Rumford was elected to the California State Assembly, where he would successfully sponsor a measure in 1949 that ended segregation in the California National Guard. Rumford is best remembered for his work on the California Fair Employment Practices Act of 1959, which created a state commission on Fair Employment Practices (FEP) and made it illegal for employers to discriminate based on "race, religious creed, color, national origin, or ancestry." His signature legislation, the Rumford Fair Housing Act of 1963, barred racial discrimination in all public and private housing in the state. Rumford's Fair Housing Act served as California's main tool in fighting housing discrimination until the passage of the Federal Civil Rights Act of 1968, which President Lyndon Johnson signed into law to provide citizens equal housing opportunities regardless of their religion, race, or national origin.

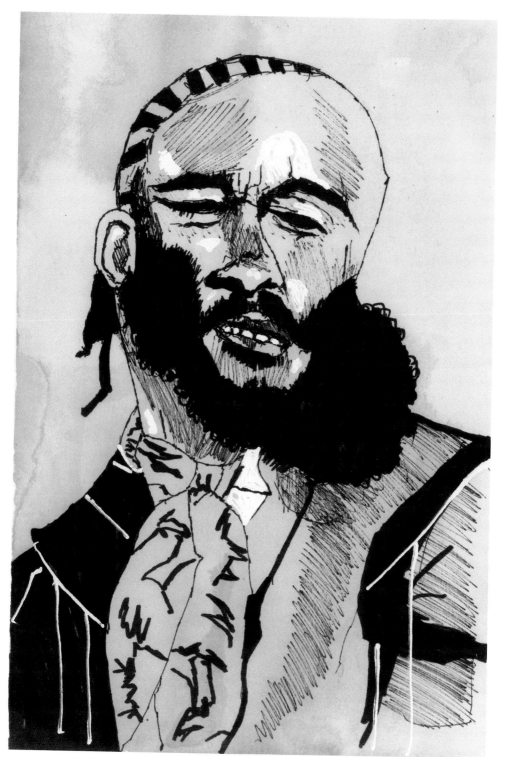

art by Joseph "JayD" Green

XAVIER AMIN DPHREPAULEZZ (Fantastic Negrito) is a singer/song-writer credited with popularizing the blues for contemporary audiences. Dphrepaulezz was born in Massachusetts, the eighth of 15 children in a conservative Muslim family. Dphrepaulezz's family moved to Oakland in the early 1980s where he soon ran away from home and landed in foster care. He spent much of his rebellious young adulthood absorbing the beginnings of hip-hop and punk music. A self-taught musician, Dphrepaulezz learned to play piano by posing as a student at University of California, Berkeley, to access the school's practice rooms where he would listen to and imitate other students who were practicing scales. He quickly began writing music, but soon left Oakland after being robbed at gunpoint, hitchhiking to Los Angeles where he auditioned for multiple record companies. Dphrepaulezz eventually landed at Interscope Records, releasing *The X Factor*, his first studio album, in 1996. Three years later, Dphrepaulezz survived a near-fatal car accident that permanently damaged his guitar-playing hand. Interscope promptly dropped him from their artistic roster, and Dphrepaulezz underwent intense physical therapy that forced him to rely heavily on support from friends and family. This led to the founding of Blackball Universe, a multimedia collective that supports emerging Black artists. Dphrepaulezz quit music for a time and moved back to Oakland to establish a farm and start a family. At first playing guitar for his children, Dphrepaulezz gradually returned to music and began experimenting with a new sound inspired by blues musicians like Leadbelly and Muddy Waters. In 2015, Dphrepaulezz entered and won a contest organized by NPR Music's *Tiny Desk* concert series, beating out nearly 7,000 other contestants and launching his second career. Connecting with what he describes as the spirituality and conviction of Delta blues, Dphrepaulezz's work has allowed him to tour the world and headline major music festivals, and has earned him three Grammy Awards (Best Contemporary Blues Album in 2017, 2019, and 2020).

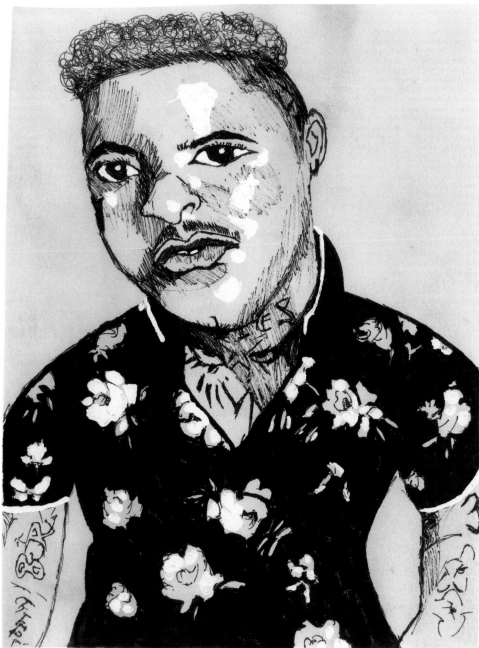

art by Joseph "JayD" Green

YANNI (AYANA) BRUMFIELD is a Black non-binary artist, model, producer, community activist, and public speaker. As a Black queer creative, Brumfield works to create visibility and representation of queer and trans BIPOC (Black and Indigenous People of Color) in the fashion industry. Born in Oakland, CA, Brumfield enjoyed the Bay Area's richness and diversity of culture while growing up. They attended schools in Oakland, San Leandro, and San Lorenzo and were passionate about dance, music, art, sciences, and physical education. They began modeling seven years ago and quickly fell in love with the runway. Brumfield's Atlanta-based mentor taught them how to produce fashion shows, knowledge that they then brought to the Bay Area. In 2021, Brumfield partnered with Creativity Explored to curate an upcycled fashion line for the exhibition *Mode Brut*, centering representation of Black and queer trans folks both in the clothing and in modeling the collection. This led to their first educator position with Flyaway Productions, where they taught young girls and gender nonconforming youth in high school about the intersections of race, gender justice, feminism, and body positivity. As a freelance multidisciplinary artist, designer, musician, and writer, they follow the flow of whatever media or idea interests them and are adept at learning as they go. Brumfield places value on visibility: they continue to host events and engage the community, centering Black joy. Brumfield is also the producer of the "Limitless Queer Fashion Show," an annual event that promotes access to fashion and art for queer folx. Throughout their work, Brumfield advocates for the idea that genuine self-expression is a form of self-love and that being who you are authentically in the world is enough.

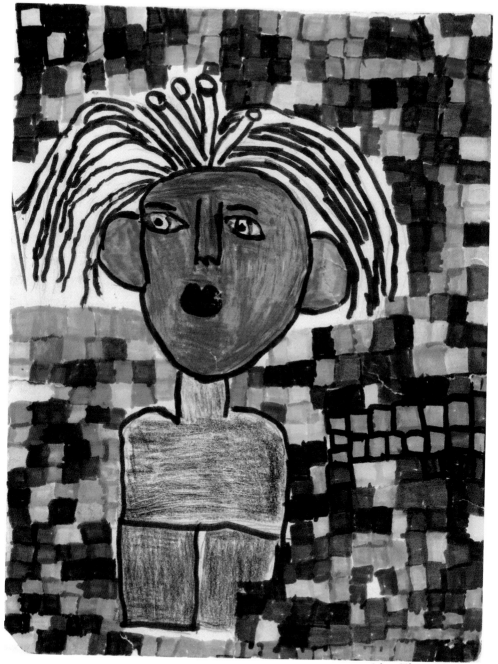

art by Alissa Bledsoe

PAMELA **Z** is an intermedia composer and performance artist who works with voice, live electronic processing, sampled sound, and video. Z was born in Buffalo, NY, and was raised by a single mother in Colorado with her three sisters. Majoring in vocal studies at the University of Colorado at Boulder, Z was inspired by a variety of musical traditions including pop and classical music (she was drawn to Baroque music in particular). Z also worked gigs in local clubs to support herself throughout college, performing in a Joni Mitchell-like singer/songwriter style. She relocated to San Francisco in the early 1980s where she quickly became known in the Bay Area's experimental music community. In her early career, Z primarily relied on her classically trained voice and an electric guitar, but as she began listening to new wave, punk, and minimalist composers, her recorded work quickly evolved. Her compositional style transformed as she began experimenting with layering vocals to create dense, complex arrangements. Around this time she began to focus on timbre, repetition, layering, and patterns, while thinking less about conventional harmony, melody, rhythm, song structure. Z's work has since become expansive: alternately described as a DJ, composer, singer, and performance artist, Z is also interested in experimental theater (she's collaboratively written and starred in an opera, *Wunderkabinet*), video art, and poetry. Z is best known for her live manipulation of media where she performs using wearable technology, creating richly layered sonic work with custom MIDI controllers that translate her physical gestures into sound and image. A collector of "found" sounds as well as various memories and sensations, Z has toured internationally and received numerous prestigious commissions and awards including a Guggenheim Fellowship, California Institute of the Arts' Alpert Award in the Arts, and a Creative Capital Fund award.

THE BLACKIFUL COLLECTIVE is a group of Black neurodivergent artists that co-create Black social and aesthetic space at Creativity Explored and beyond. Through regular virtual and in person social gatherings, workshops, exhibitions, and publications, Blackiful empowers its members to cultivate individual and collective self-determination.

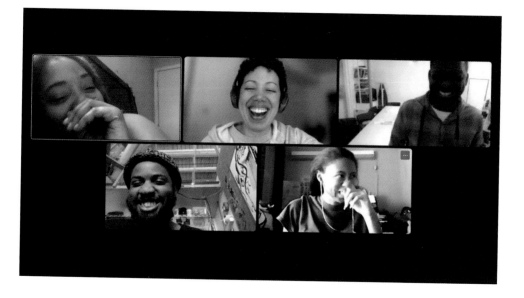

Pictured left to right, top: Alissa Bledsoe, d. Wright, Joseph Omolayole
bottom: Joseph "JayD" Green, Adrianna Simeon
Not pictured: Laron Bickerstaff, Vincent Jackson

ADRIANNA SIMEON makes paintings of people, flowers, fruits, and vegetables. She makes drawings of animals (sea animals and African animals), Disney characters, and anime cartoons using watercolor, acrylic, and permanent marker. Simeon also uses her iPad and Photoshop to create digital art.

ALISSA BLEDSOE describes her work as sculptural. She challenges herself and takes inspiration from pictures, drawing from observation. When she is not making sculpture, Bledsoe makes drawings with permanent marker. She also channels her creativity into candle-making and digital collage.

d. WRIGHT is interested in the limits of language. Through drawing, installation, and experiments in sound, d. explores what it is like, as subject, to be regarded as object. d. lives and works in Chicago, IL.

JOSEPH "JayD" GREEN is an African American artist from San Francisco, CA. He uses his art practice such as painting, drawing, and digital art to make portraits and figures.

JOSEPH OMOLAYOLE describes his work as "off the charts." He likes to work with acrylic paint and charcoal and pays special attention to value (light to dark) for the image to pop out. He likes to print on fabric and to play with patterns and shapes. Omolayole likes to work with fabric that can help him design a beautiful image, and translate his designs into a beautiful dress. When he's not making soft sculpture, Omolayole makes nature drawings of flowers and other flora. His designs feature different shapes based on nature and culture; Omolayole draws inspiration from various African and Asian cultures.

LARON BICKERSTAFF mixes his own observations with a pop influenced love of the brand names that populate everyday life: celebrities, stores, food and drink, and institutions. Bickerstaff is known for his use of bright geometric shapes to assemble his abstract and stylized figures and scenes.

VINCENT JACKSON's work brings people joy. A self-described "art psychologist," Jackson is trying to bring back the culture of quilting (it doesn't have to be a bedspread, it can be a garment). He feels he has mastered everything at Creativity Explored. Everybody knows Jackson all over the Bay Area. He has brought power (not nonsense) to Creativity Explored. He plans to take his practice further.

ACKNOWLEDGMENTS

BLACKIFUL would like to thank Roshann Pressman, Eric Larson, Linda Johnson, Paul Moshammer, Megan Hover, Mai-Thy Vuong, Ann Kappes, Ajit Chauhan, Shilpa Dutta, Aileen Louie, Jaime Wong, Kate Hope, Eliot Rattle, Star Baker, and all of the Creativity Explored staff for their unwavering support. Blackiful also wishes to thank Jennifer Joseph, Cameron Mankin, Juan Castille, and the many Black changemakers past, present, and future for their invaluable contributions to this work. To Pop Pop, Auntie M, Ndubs, The David, Josie, Nina, and Nana—thank you. May the funk be with you, always.

RESOURCES
for further reading

Blackiful appreciates everyone involved with BlackPast.org, as well as the University of San Francisco students and faculty who put together the book and blog (usfblogs.usfca.edu/sfchangemakers), *Changemakers: African Americans in San Francisco Who Made a Difference*. Blackiful also wishes to recognize the important work of students and faculty who compiled *The Berkeley Revolution* online digital archive (revolution.berkeley. edu).

The text in this book is set in Atkinson Hyperlegible, an award-winning typeface named for Braille Institute founder J. Robert Atkinson that makes written materials easier to read across the entire visual-ability spectrum.

creativity explored
ART CHANGES LIVES

Creativity Explored is a studio-based collective in San Francisco
that partners with developmentally disabled artists to celebrate and nurture
the creative potential in all of us.

www.creativityexplored.org